Pieter Bruegel's

Tower of Babel

The Builder with the Red Hat

Prestel

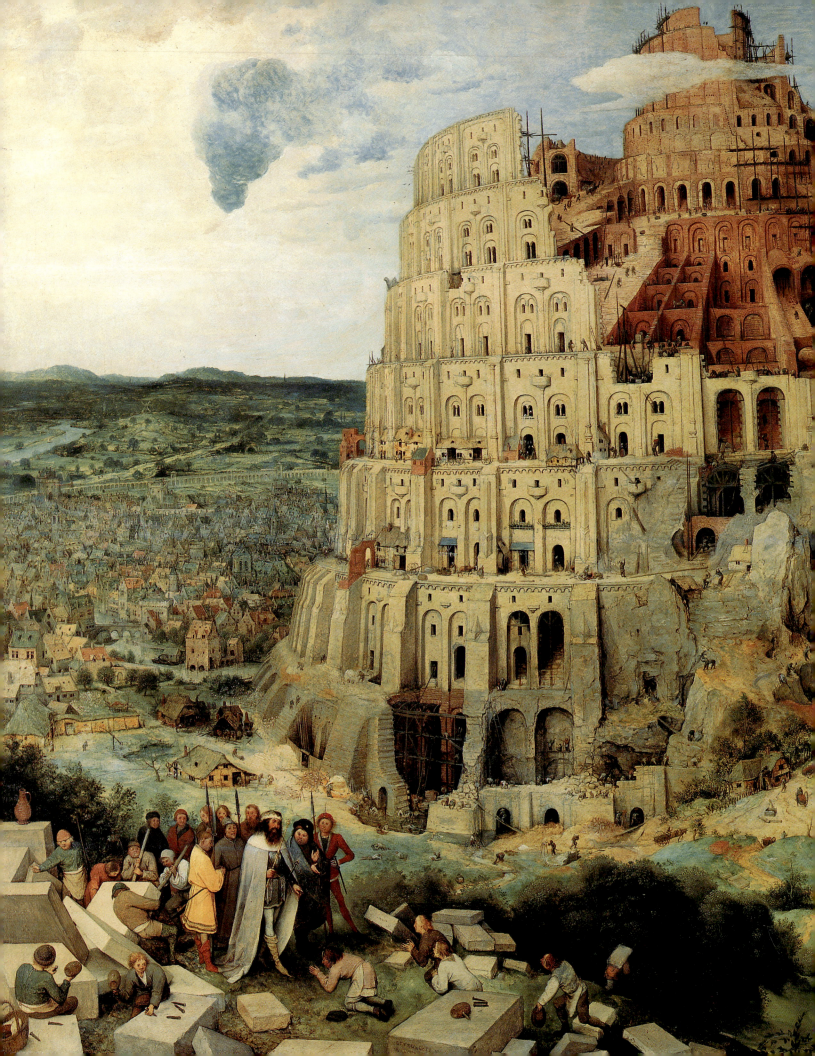

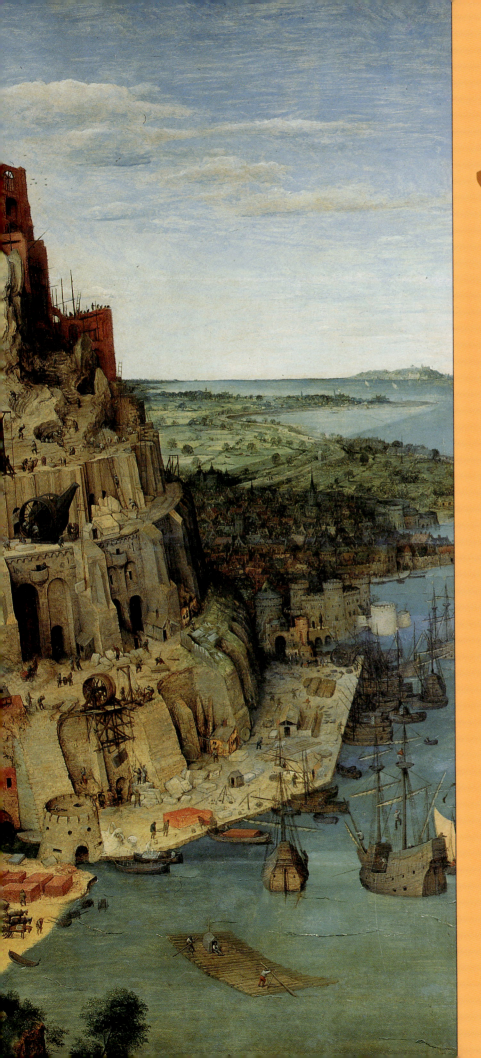

Welcome to the largest building site in the world! Welcome to the Tower of Babel. It was actually built some 3,000 years ago in the Kingdom of Babylon, which today forms part of southern Iraq.

However the painter, Pieter Bruegel, decided to set the story in his own time and place – in Antwerp – a city, in what today is Belgium, located on the banks of the River Schelde, not far from the open waters of the North Sea.

Let us go back to the year 1563. This was a period of unrest in which the Spanish occupied the Netherlands and tried to force their Roman Catholic faith on the people, even though they were much more interested in the convictions of the Protestant reformers, such as Martin Luther, John Calvin, and Huldreich Zwingli.

3

In those days, Antwerp was one of the largest cities in Europe with more than 100,000 inhabitants. There, everything danced to the tune of the merchants. New trade routes had been discovered, enabling ships to circumnavigate the continents of Africa and Asia and to sail across the Atlantic to America. To the merchant ships that sailed these new routes, Western European ports, like that of Antwerp's, were much more easily accessible than those in the Mediterranean, such as Venice and Genoa, which before had played such an important role in trading and shipping.

Due to its favorable location, merchants turned Antwerp into the leading city of commerce in the Low Countries, making it the center of the entire Spanish Empire, which at that time encompassed half the globe. Huge fortunes could be made in importing spices from the Orient, or wood and grain from the Baltic countries as well as shipbuilding or manufacturing equipment necessary for long sea voyages, and transportation in general.

Plots of land and houses were also in great demand since a large number of foreign merchants of Italian, French, English, and Portuguese extraction wished to do business in Antwerp. Naturally, these new inhabitants were readily noticed because of their foreign tongues, peculiar clothes, and unfamiliar customs. But, the people of Antwerp became more and more estranged from one another, while their desire to attain prominence and wealth grew to monstrous proportions.

4

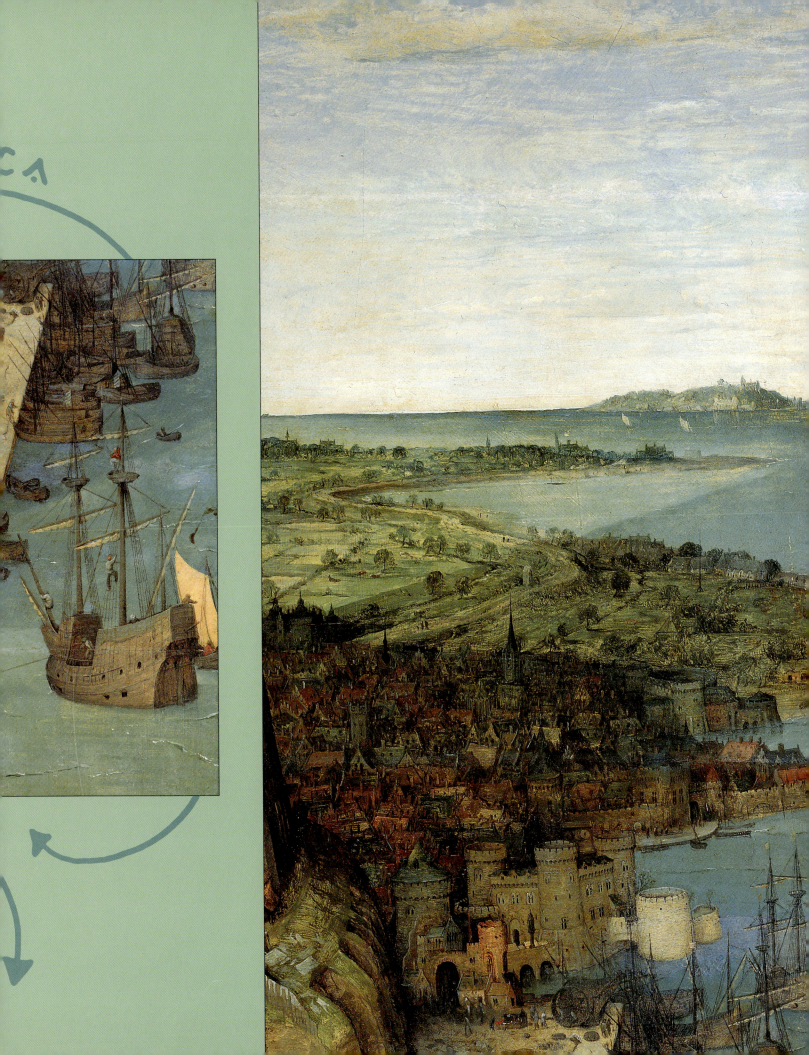

The immense wealth and growth of the city, the mix of languages, and the foreignness felt amongst the population must have reminded Bruegel, and many of his contemporaries, of how ancient Babylon was described in the Bible, which tells of a people who planned to build a city and an enormous tower that would reach up to the heavens. They wanted to make a name for themselves by erecting such a magnificent structure. All the people involved were to take pride in their joint accomplishment, so that no one would think of moving to anywhere else in the world. God, however, did not like the impudent people encroaching upon his celestial realm, so he stepped in and brought confusion into their language. Before, the people spoke only one language and understood each other. Suddenly, things became completely different and people no longer understood one another. Work on the tower came to a halt and the people dispersed to all corners of the earth. The city from which they fled was given the name Babel, which means "confusion."

In front of us, lying at the foot of the tower, is the city of Antwerp. But it does not appear to be nearly as chaotic as the biblical Babel. Here, we see a tranquil city surrounded by beautiful countryside located near the open sea. Why, in 1563, did Pieter Bruegel paint Antwerp as the city with the Babylonian tower? What fascinated him about the hundreds of people who worked on this gigantic structure?

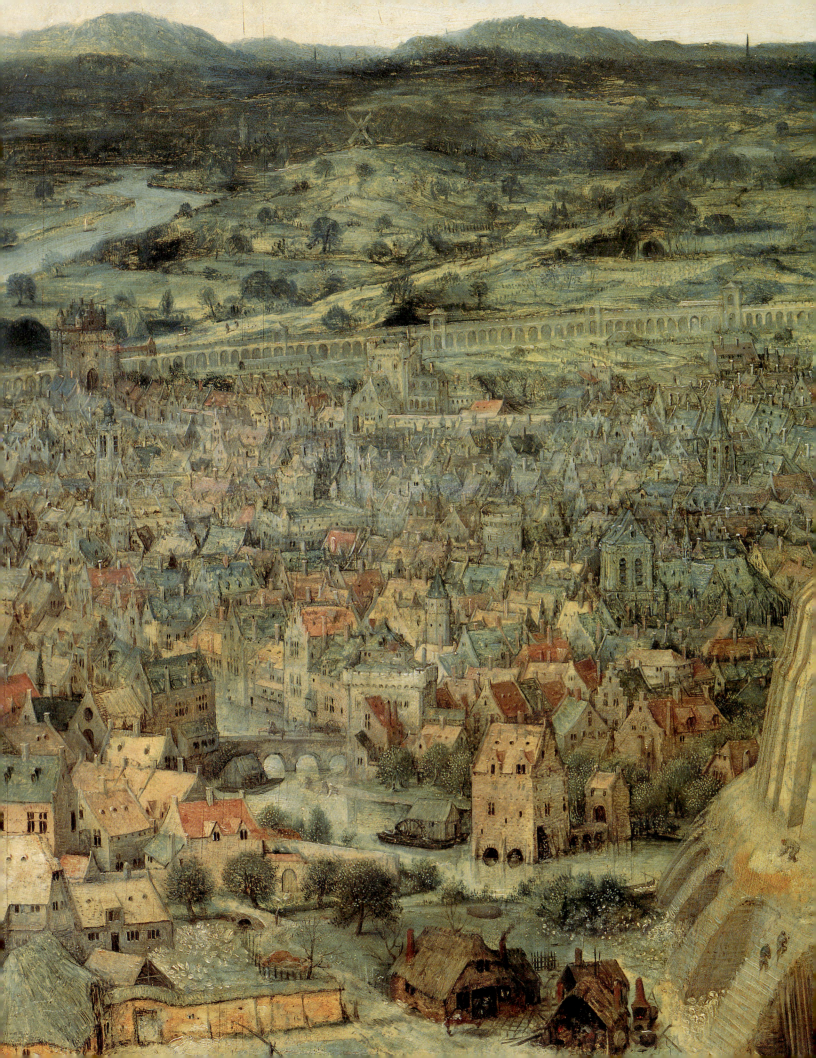

We should take a closer look. But who will be able to answer all our questions or perhaps even walk us through the painting? Let us ask the man wearing the red cap and the apron who, at the bottom left-hand part of the picture, is giving instructions to the others as they move the large stone blocks with the poles. Do you think he will tell us anything about the scene?

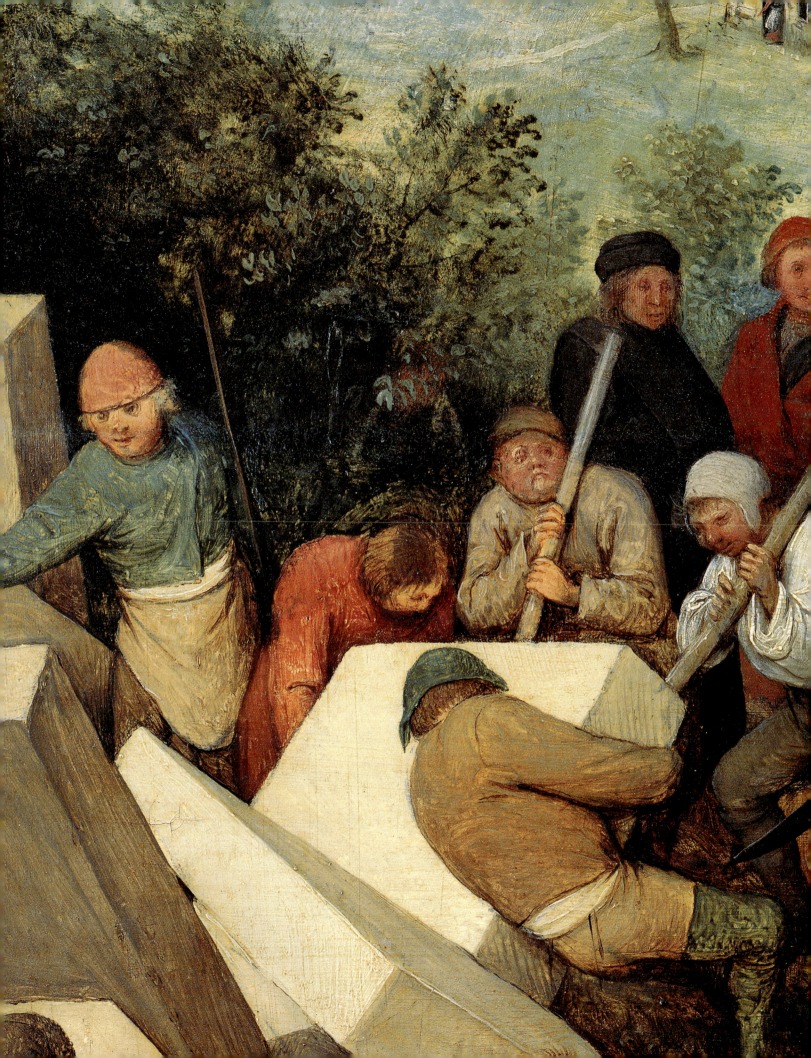

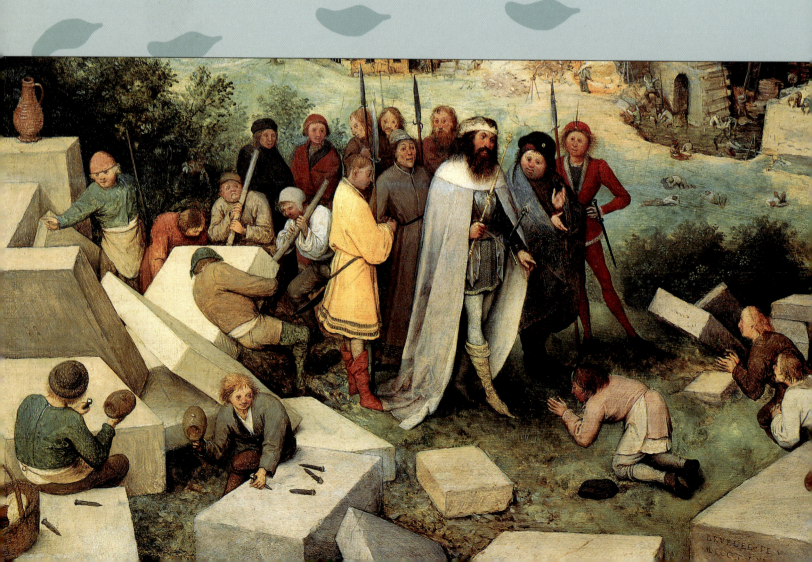

"**R**ight now is particularly inconvenient. You can see yourselves how hard we have to work here. And our wages are based on the number of blocks we move a day, so we can't afford to take long breaks. Besides that, an important visitor has just arrived – King Nimrod, the ruler of Babylon, and his entourage."

Bruegel painted him into the picture because, according to the Bible, it was this eminent gentleman who encouraged the people to build such a tower.

"Today the king has come, resplendent with his scepter and crown, to watch work being done on the tower. The man next to him in the dark blue cape wearing a black hat is the master builder who oversees the construction. For a short time now, these men have been known by the title "architects". But, actually, they are trained carpenters and stonemasons who have been particularly successful. You can tell that he is well-off by his sheer size! In contrast, the priest wearing a long, plain garment looks thinner and more worried, and stands somewhat impartially behind the king to the left. Does he sense that the Lord God does not approve of this tower, built by the hands of mortals, reaching up to the heavens?

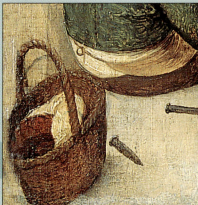

The other men who are guarding the king with their long halberds have nothing to fear from us stone-movers and stonemasons. You can see yourselves how some of my colleagues have fallen to the ground on both knees before the king. The others continue to work because we have so much to do. We will be lucky if we can finish it all. We still have to move so many sandstone slabs with our iron crowbars so that they can be worked on with iron chisels which we hit with our stonemasons mallets made of beech wood. Some tools have been left on a block of stone at the bottom right-hand corner of the scene. These have been used to engrave Master Bruegel's name: BRUEGEL FE MCCCCLXIII, which means "Bruegel made this in the year 1563."

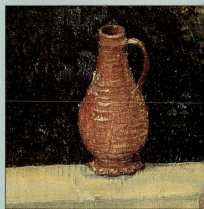

I myself have never seen the painter Pieter Bruegel, but many of my colleagues tell me that he has been to many construction sites and has made a lot of drawings of us at work. He seems to be very interested in what we simple people do: how the craftsmen, the farmers, and the wage earners work, live, and celebrate. Otherwise, he never would have been able to paint this picture which depicts our work in great detail. He even thought of including our basket of food in the lower left-hand corner of the picture and our jug of water for the few short breaks we take that are so vital!

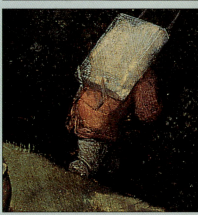

You may have asked yourselves why the large blocks of sandstone are not cut directly at the building site. Well, it's really quite simple. We prefer to do this in the quarry (which is not shown in this picture) because it saves us from having to transport the pieces that are cut from the stone when it is carved. I'm sure you can imagine how heavy the stone is that the worker is carrying on his back down the hill. Let's follow him down the path to the horses that are waiting with their flat carts, where I can show you the entire building site from up close.

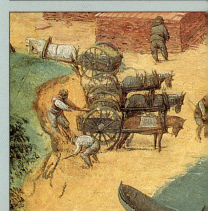

We may sit there on the stone blocks for a moment and enjoy the view of the harbor and the boats.

It's unbelievable the amount of building material that is necessary to construct such an enormous skyscraper. A lot of it must be transported to the site by sea, then unloaded and transported over land the rest of the way.

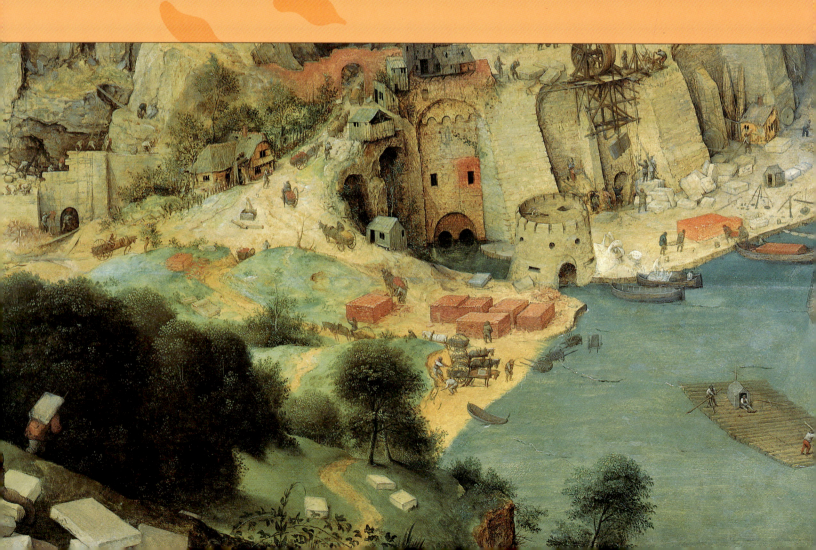

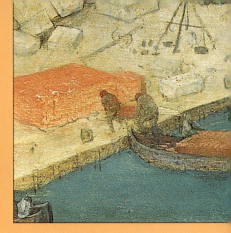

Red bricks are transported from outlying regions on barges which travel along the inland waterways. The amount of clay needed to make the bricks for the tower cannot be found here. Neither do we have the space for such an undertaking. This means that we buy the bricks to be used inside the tower and have them transported to the building site. They are then carried to the shore on wooden stretchers, where they are stacked in huge piles, and eventually transported to their final destination on horse-drawn carts.

The mortar mixers combine **lime** with sand to make the mortar used by the bricklayers and the plasterers. This material is transported from the lime kilns in small boats and is stored on the shore near the small defensive tower.

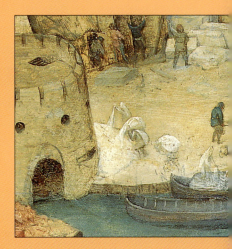

Although we are building mostly in stone, **wood** is still required in large amounts, as you can see by the quantity that has just arrived in the harbor. Various kinds of saws are used to cut the logs into beams, boards, gutters, and shingles. Tinsmiths also use wood to make wheels for the carts and the cranes. Besides that, we need troughs, wooden stretchers, wheelbarrows, and barrels for a variety of tasks to do with transporting and digging. Wood is the most important material for making scaffolding and supportive frameworks, hoists and cranes, ladders and plankwalks. All these devices, as well as the stonemasons' lodges, which I will tell you about later when we climb the tower, are made by carpenters.

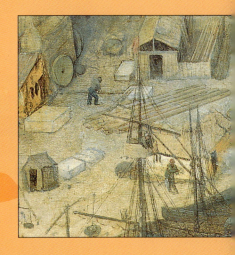

For some time now we have not been able to get enough **sandstone** from the nearby quarries for the tower's colossal facade. So, most of the sandstone must be brought in by boat after it has been cut in the quarries. You can see the sandstone slabs below in the harbor where they will be left until they can be hoisted up to the next level by the cranes.

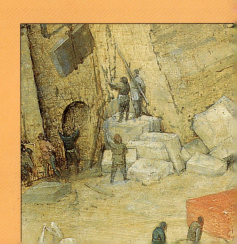

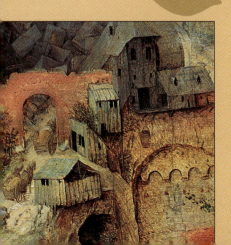

Now it is time for us to examine the tower up close. We will follow the horse-drawn carts that are transporting sand, lime, and bricks from the harbor over the ramp and into the tower, where they wend their way around it like in a spiral. The buildings that flank both sides of the road are stonemasons' lodges. Some of them are only used for storing tools, while others function as shelters in which stones requiring careful workmanship can be cut without the rain or the cold interfering with the stonemasons' work.

Large lodges (like the first one that can be seen on the left-hand side of the road or the one built at the foot of the tower or those perched above the tower walls) belong to individual guilds. A guild is a sort of association, in this case of construction workers who practice a particular trade. Therefore, lodges can belong to stonemasons', carpenters', and bricklayers' guilds, which are run by foremen and which often disband once a project has been completed. Alternatively, they work together as a group and move from one building site to the next where they offer their services until that project is finished. A lodge attendant (a kind of caretaker) is responsible for keeping each one orderly. This is where meals are had and where the few craftsmen sleep who do not live down in the city. And, this is the place where the journeymen celebrate the completion of their work with the attendants, the buildingmaster, the guild foreman and his deputy. Not much celebrating has taken place at this building site since, as you can clearly see, everything is just getting started here. But, nothing will ever be completed.

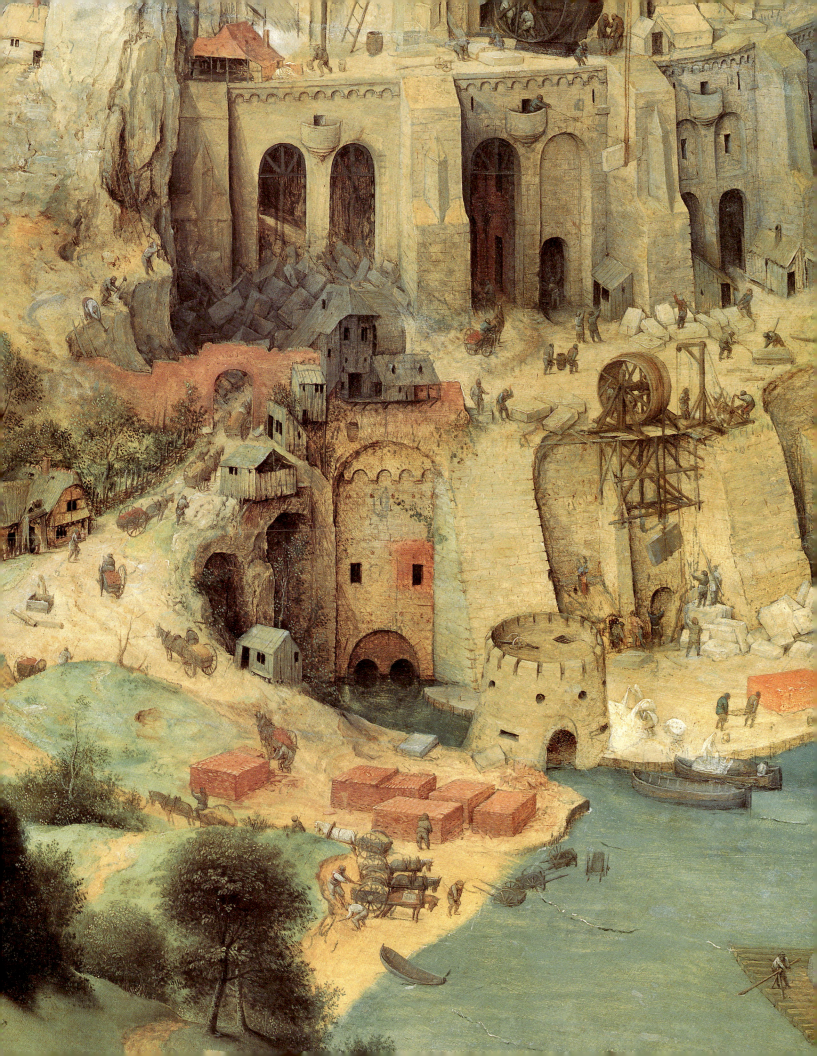

Be careful and watch your step! This is where it begins to get dangerous for now we have reached the cranes that lift the slabs of stone story by story up the tower. The carpenters built the wooden framework that hugs the tower walls and supports a crane with a man-driven tread mill next to which is a hoist with a wince. At least four workmen get inside these wheels (as can be seen in the large crane one story above us or in the harbor) to lift the load upwards with their own bodyweight.

Over the years we have come up with devices designed to ease the burden of carrying building materials. Just look around: there, for example, two men are toting a wooden barrel with the help of two poles. Others are using special straps or stretchers.

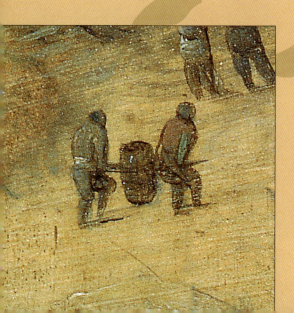

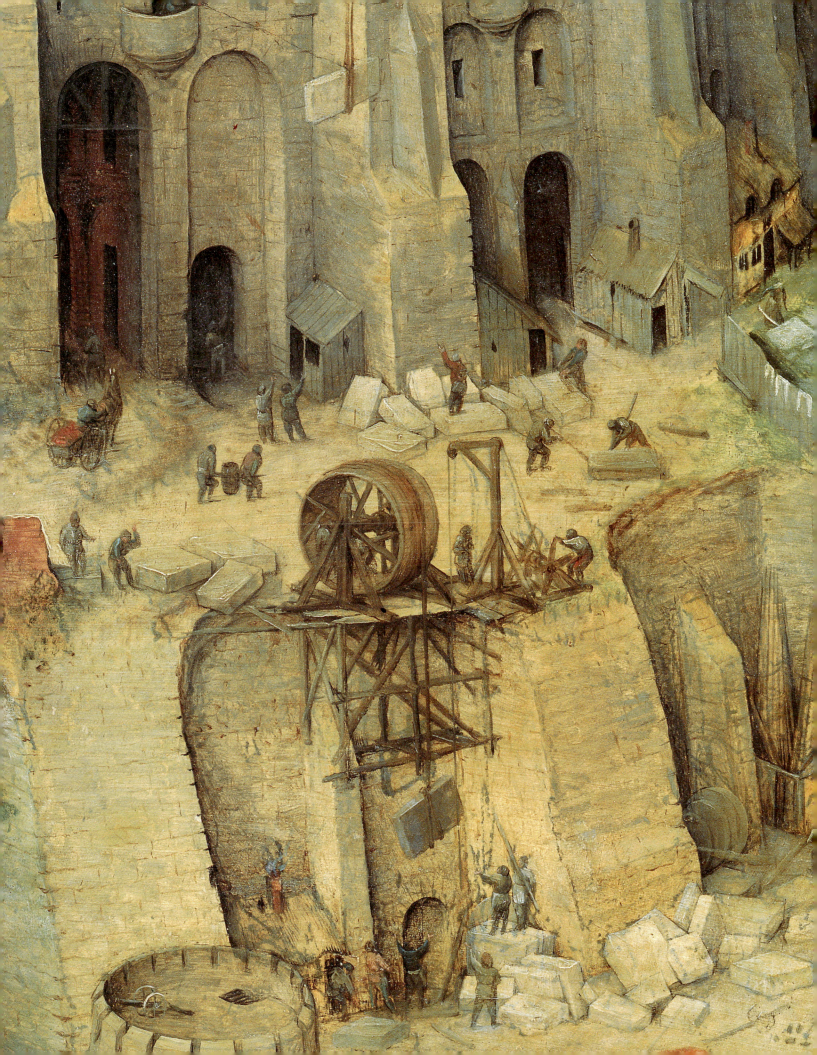

et's go further into the tower through the arch, next to which a man is standing on a small balcony struggling with a rope to keep a slab of stone from colliding into the buttress. Up here on the second floor we can see how the bricklayers are working on the arches. The carpenters are still constructing the supportive framework for the right-hand arch, which will carry the immense weight of the stones until the arch has been completed and can remain in place without such support. To the right of this, carpenters are erecting wooden scaffolding for the plasterers: boards will be laid on outriggers, which will temporarily be closed in the masonry and removed later. That is how the bricklayers and plasterers work their way up the scaffolding, little by little. And if you look up high above the clouds, you can see scaffolding there, too.

We can get up there using the stairs which lead into the building from the left, passing through the recently erected barrel vaulting that is still being supported by the wooden framework. We are getting higher and higher. Now that we have reached the third story, you will be able to find your own way up from here. If you wish, you can try to make it to the very top, where you will have an excellent view of our magnificent structure. Perhaps from there you can imagine how King Nimrod and his building master envision the tower in its finished state.

But, I must leave now. I have already been away from my work for too long, and must be getting back."

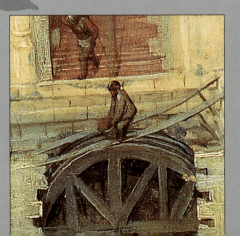

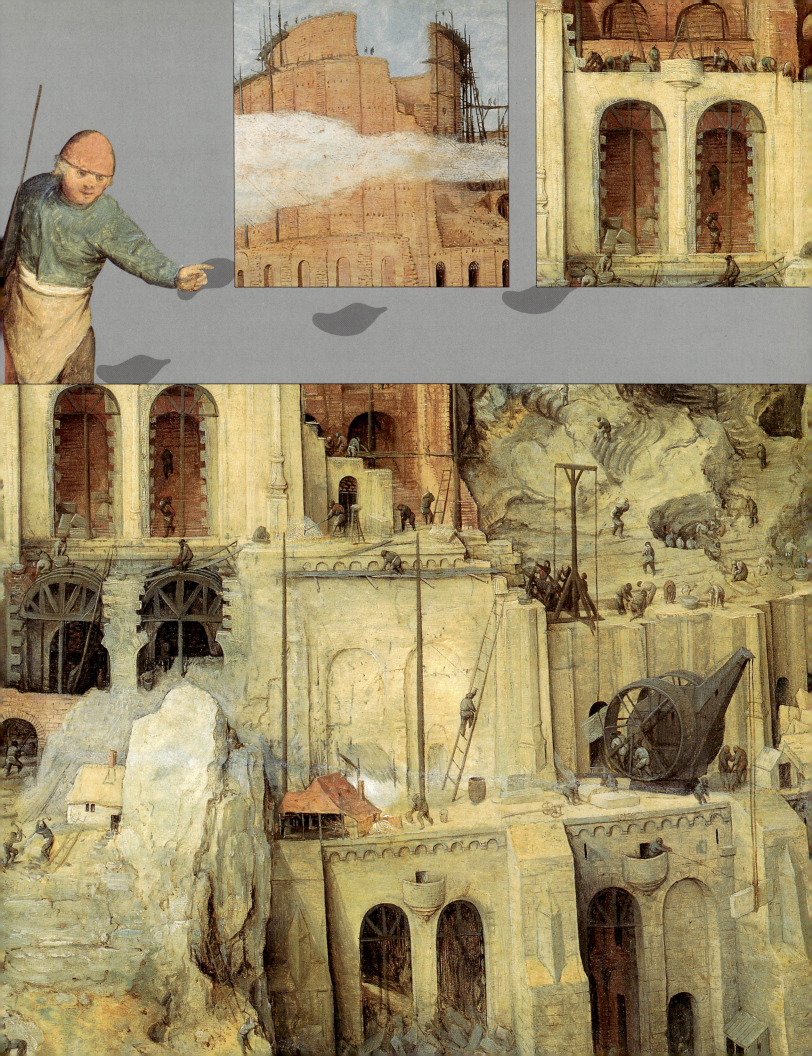

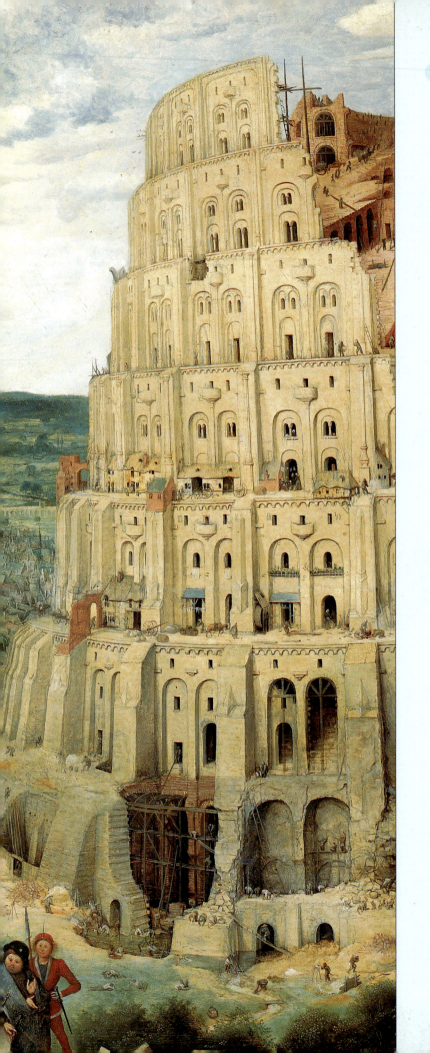

That was a really nice tour that the stonemason gave us. We have learned a lot about the work that is done here at the construction site, but the building itself remains a mystery. Why, for example, are so many different parts of it being built at the same time – far below at the base of the building and high above the clouds? Why is the construction on the left-hand side of the tower much more advanced than on the right? Why is part of the facade already being put on the top level even though the masonry work behind it has not yet been completed? And who can explain the crumbling boulders, which in some places have been incorporated into the structure and in others have been removed? These are undoubtedly questions that neither the corpulent building master nor his patron, King Nimrod, can answer. But, we should not forget that the actual engineer of this building extravaganza is the painter, Pieter Bruegel. He deliberately "built" the Tower of Babel into his picture in order to illustrate what is described in the Bible.

We must remember: God jumbled the language spoken by the different people so that they could no longer understand each other. Each worker is doing what he thinks should be done without knowing what the final outcome of the whole project is to be. Indeed, it will not be long before the people – as the Bible describes – stop construction on the tower and disperse to the far ends of the earth. Are the men shown lying on the grass, as if exhausted, intended to be the first ones to give up?

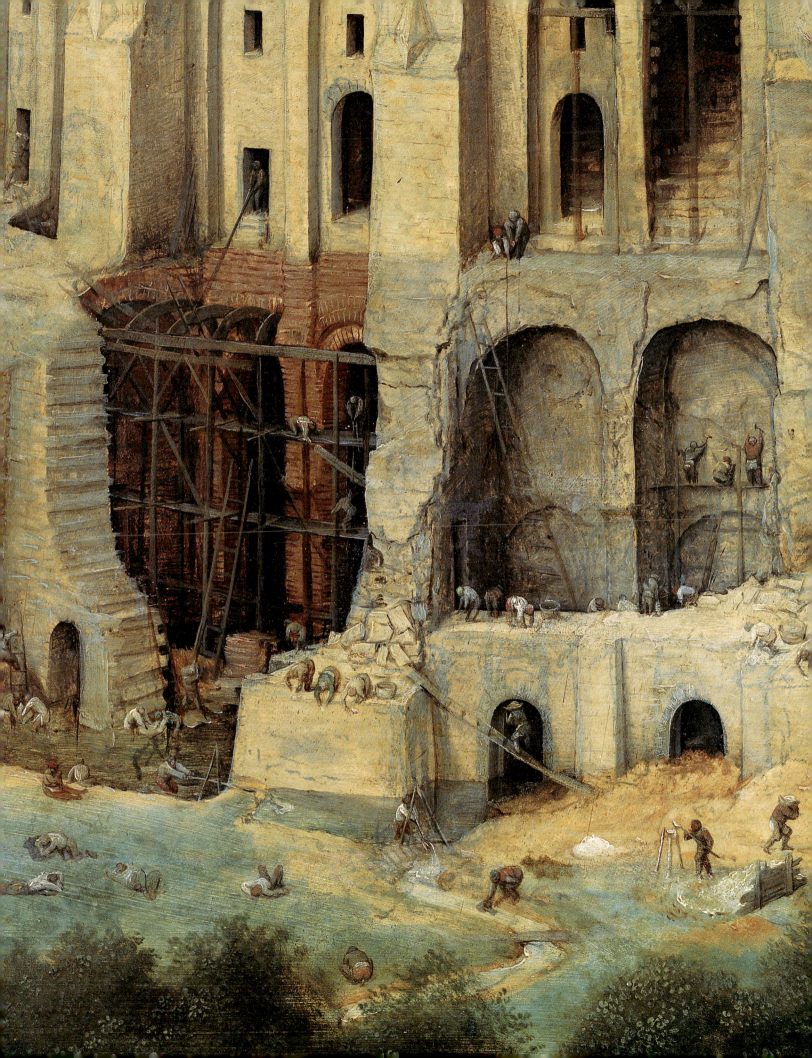

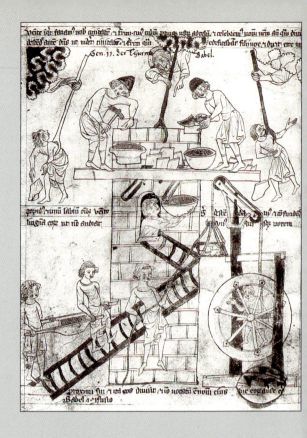

Even before Pieter Bruegel's time, many artists from various countries depicted the construction of the Tower of Babel. It has been, and shall remain, a favorite motif because it requires great skill and innovation on the part of the artist. How, for example, should one paint a colossal building in an expansive land-scape? How should the artist convey that it is a radically flawed construction because the men working on it can no longer communicate with each other?

More than 200 years before Bruegel, a Bohemian master drew this Babylonian tower with a quill: God, with his heaven[l]y helpers, is shown going to great lengths with long, forklike instruments to keep th[e] ambitious craftsmen from entering the Kingdom of Heaven.

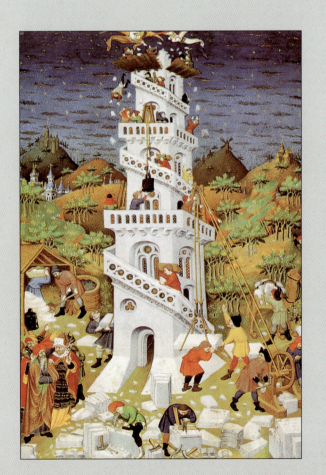

Nearly 150 years before Pieter Bruegel, a French master illustrated a prayer book with this square Tower of Babel. Many elements of this painting are familiar to us: King Nimrod, here depicted with a long beard, stonemasons and lime mixers at work, the conveyance of stone slabs – here, instead, with camels and winces. High above, where some men are working on the scaffolding, angels try to prevent them from building the skyscraper – and from realizing the hubristic design of the people.

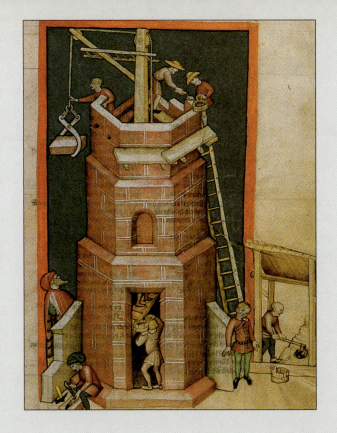

A Swiss master also painted the tower some 150 years before Bruegel's picture. The journeymen are working eagerly to erect a tower (this time, a pentagonal structure) consisting of red bricks.

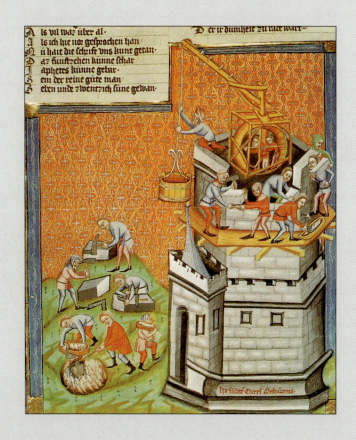

Here, too, we can recognize many things: the crane driven by a treadmill, stonemasons, mortar mixers, and brick layers. But the master who painted this tower in a book, fewer than 200 years before Bruegel, was scarcely interested in the landscape surrounding it. Instead, as a backdrop behind the green hill, we can see an ornately decorated tapestry.

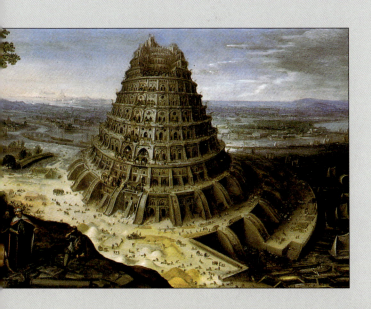

This picture was painted by Lucas van Valkenborch the Younger several years after Bruegel painted his. Was Van Valkenborch aware of the version painted by Bruegel, his fellow countryman? In which painting does the Tower of Babel look the mightiest? In which picture does it appear most chaotic?

When painting his great work, which is now in the possession of the Art Historical Museum in Vienna, Pieter Bruegel executed at least one other painting with the same motif. Today, it hangs in the Boijmans Van Beuningen Museum in Rotterdam, The Netherlands.

This painting depicts a somewhat more ordered tower. Bruegel makes use of another trick to convey the impending doom of the fated construction: he paints a crooked tower, with dark clouds gathering which announce an imminent thunderstorm. But, are there no signs of King Nimrod and his entourage? In this version men are shown working where the king appears in the Viennese painting. Where might we find the king?

This is a difficult task owing to the painter's little joke! Look carefully at the third story of the tower, where we can see – in miniature – a long procession of people inching its way along the terrace. The king must surely be the person walking beneath the red canopy in the middle of the procession.

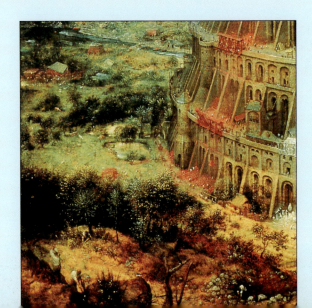

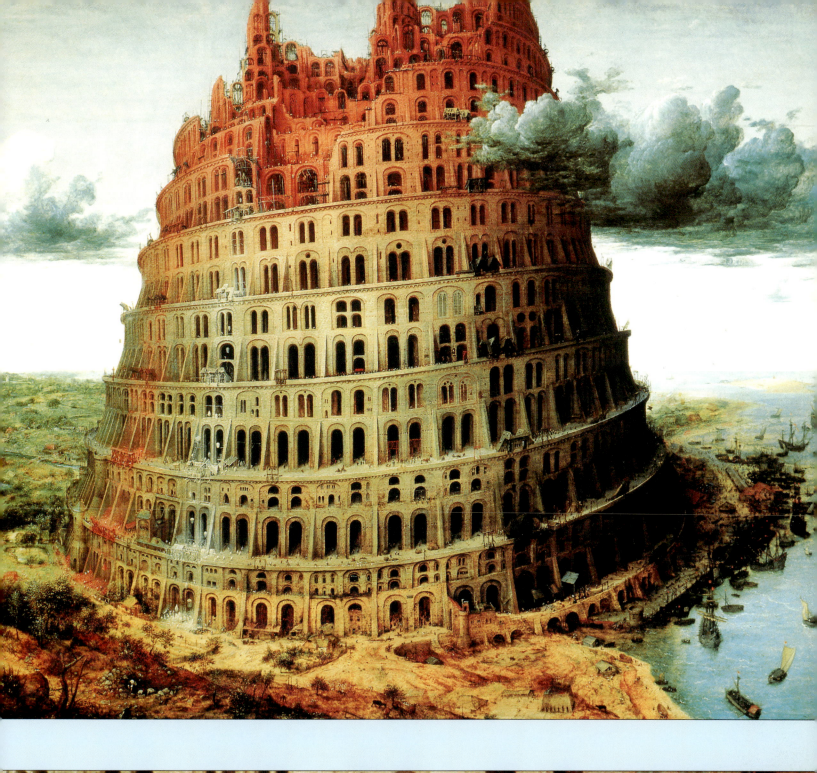
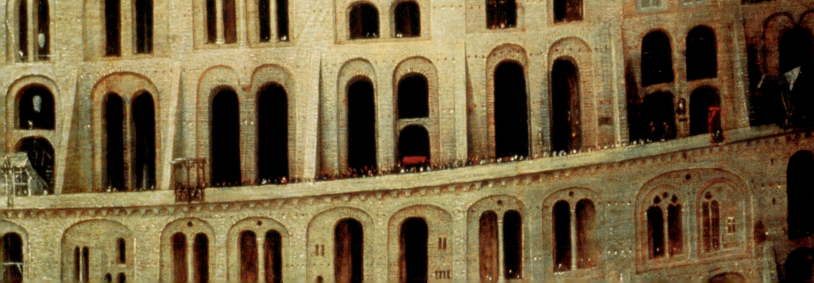

Let us return to the great city of Antwerp where Bruegel, now aged 30, has lived for at least 12 years. He moved here from Breda, in Holland – where he was born some time between 1525 and 1530 – to be an apprentice to Pieter Coecke van Aelst. He could not have chosen a better place because here, in the flourishing city of Antwerp it was not difficult to find patrons interested in purchasing works of art. Coecke was one of the most highly respected painters in the city.

When Bruegel finally completed his apprenticeship in 1553, he was drawn to Italy, where he stayed for two years.

After returning to Antwerp, he began to earn his living largely by working for Hieronymous Cock. He made preliminary drawings for him to be used for copper etchings that Cock had printed in large editions and sold.

Bruegel did not begin to paint until around the age of 30. At last, he no longer had to produce works that appealed to the masses! He had become so famous in the meantime that he found buyers who wanted him to produce pictures with unique motifs. His clients were willing to pay a considerable amount of money for his works. By 1563, Bruegel's time in Antwerp was coming to an end. Soon, he would move to Brussels to marry Mayken Coecke, the daughter of his master.

What is he trying to tell us about the city of Antwerp by depicting the Babylonian Tower in his painting just outside the city walls?

He portrays the city endearingly in his painting – it is a peaceful scene, bathed in the most radiant light of a pleasant summerday, set in a vast landscape, but overshadowed by this mighty tower. Sailboats glide gently out into the open sea and along the coast, which is dottd with meadows, fields, houses and churches beyond. He depicts the glory of life in an idyllic world.

Bruegel sees this world as being threatened by the ambitions and vanity of its inhabitants, who have allowed their desires to become so great that they reach up into the sky. Destruction is brewing, like the ominous clouds in the sky. What can a painter do in a country that is on the verge of ruin owing to the fight for political power, the conflict of religions, and the peoples' insatiable desire for more wealth? He can do only one thing: paint, paint, paint.

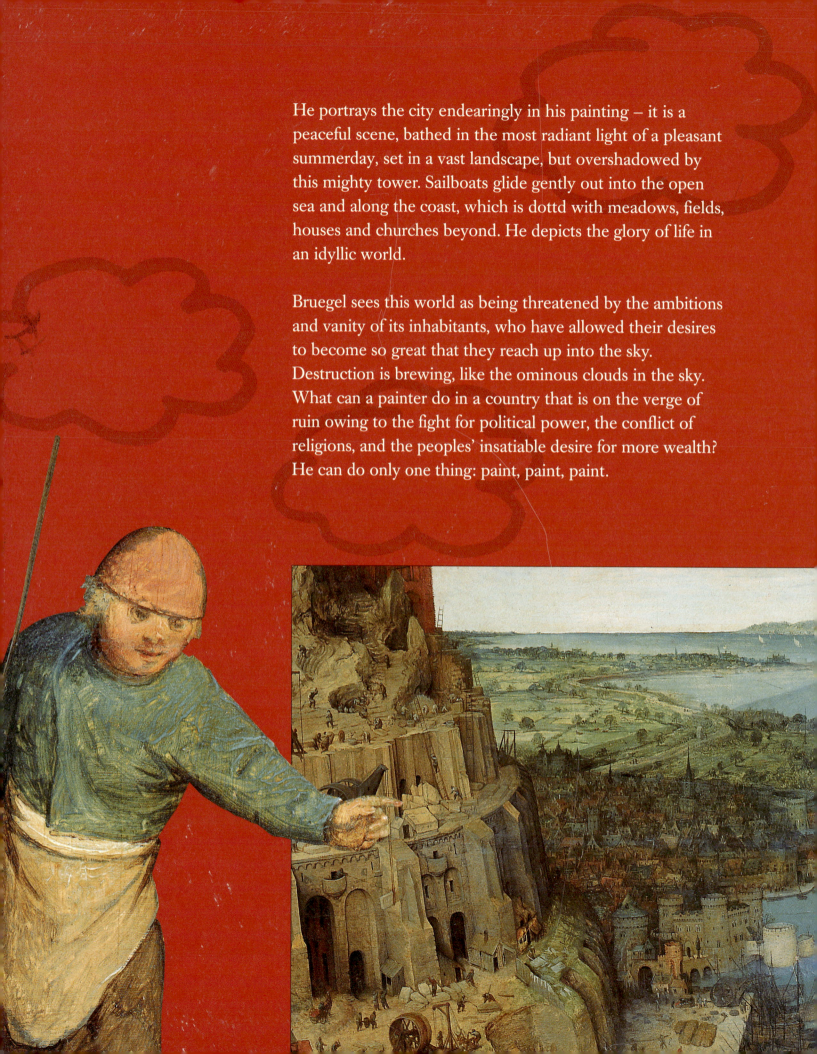